W9-BVM-997

WOMEN IMPRESSIONISTS

P O S T E R B O O K

Pomegranate Calendars & Books, San Francisco

Pomegranate Calendars & Books
Box 808022
Petaluma, California 94975

Text and illustration reproductions
© 1989 Pomegranate Calendars & Books
All paintings reproduced in this book from the Musée d'Orsay and the Louvre in Paris
© Musées Nationaux.

ISBN 0-87654-434-0
Library of Congress Number 88-64076
Pomegranate Catalog Number A530

For more information on Pomegranate's other publications, including notecards,
postcards, posters, calendars, books of days, address books, and other books, please write
to Pomegranate, Box 808022, Petaluma, California 94975.

Cover design by Bonnie Smetts
Printed in Korea

CONTENTS

INTRODUCTION

WHEN the term ''French Impressionism'' is used, the artists who generally come to mind are the famous male painters of that style, specifically Claude Monet, Auguste Renoir, Camille Pissarro, Edgar Degas, Alfred Sisley, Edouard Manet and Paul Gauguin. Upon reflection, some might also recall the work of Gustave Caillebotte, Armand Guillaumin, Stanislas Lepine, and others. ''American Impressionism'' immediately seems to refer to Childe Hassam, Theodore Robinson, Phillip Leslie Hale, William Merritt Chase, Maurice Prendergast, Frederick Carl Frieseke and Robert Vannoh.

Absent from these impressive lists of names are the women Impressionists, whose contribution to painting in the late nineteenth and early twentieth centuries was as significant as their male contemporaries', but whose struggle for acceptance within the male-dominated art world was uniquely theirs. Women were expected to find life's fulfillment in their roles as wives and mothers, as needlepointers and homemakers, as supporters of their working husbands. A woman who elected to be a painter faced the possibility of ostracism by her peers, condescension from her family and biased reviews from chauvinistic critics.

Of course, some rare women chose painting and other art fields as lifelong careers, enjoyed financial success and widespread exposure and were able to maintain solid relationships with their friends and family. However, their place in art history, with few exceptions, still continues to be judged as inferior to male painters', as critics' attitudes have had far-reaching effects on the evaluation of women's art.

The nine women Impressionists represented in this poster book enjoyed varying degrees of public success, and their personal lives varied economically and socially. But all of them had in common a deep commitment to their art and a desire to have it seen and judged by the same rules applied to the work of male painters.

MARY CASSATT (American, 1844–1926)

Mary Cassatt is certainly the most famous woman Impressionist, and perhaps the most famous woman painter of all time. She was born in Allegheny City, Pennsylvania, near Pittsburgh, to a well-to-do family—her father was a stock broker and real estate investor. The family moved to Europe in 1853, where they lived for two years, and then returned to Pennsylvania, and eventually settled in Philadelphia. Mary Cassatt attended the Philadelphia Academy of the Fine Arts from 1861 to 1865, and, exasperated with the traditional academic restraints imposed by the academy, took off for Europe for further study in the summer of 1866, much to the dismay of her parents.

Cassatt studied briefly with the painter Charles Chaplin, who was *the* acceptable teacher for young ladies, but she soon left him to pursue more independent study. She worked copying masters' paintings at the Louvre and later extended her practice to painting outdoors, out of the studio, perhaps influenced by what she saw of the work of Edouard Manet and Gustave Courbet. Cassatt had to return to Philadelphia at the outbreak of the Franco-Prussian War in 1870, but she went back to Europe in 1872 and settled in Paris in 1873.

In 1874 the ''Impressionists'' (so named by an uncomplimentary critic)

held the first of what were to be eight unjuried exhibitions, organized by the avant garde painters themselves and not subjected to the judgment of a selection committee. When the second was presented two years later, Cassatt's paintings had been accepted into the officially sanctioned, established shows known as the Salons, and her work had been seen by Edgar Degas, one of Paris's foremost new painters. In 1877, after the Impressionists' third exhibit, Degas visited Cassatt and invited her to join them in rejecting the rigid structure of the Salons by participating in their next exhibition. Cassatt accepted without hesitation, and she showed work in four of the five remaining exhibitions.

Mary Cassatt and Edgar Degas became and remained very close friends for the rest of their lives. Degas was not an easy man to befriend or tolerate, as he was intolerant himself, domineering and untrusting. But he found in Cassatt a soulmate of sorts, and, despite several long-lasting disagreements, Degas and Cassatt provided mutual support and encouragement. Cassatt clearly was influenced by Degas in her painting, and Degas clearly was moved by Cassatt's work, for he afforded her more respect than he evidenced toward most other painters.

Cassatt became more and more successful in Europe through her many canvasses and through her association with the new painters of Paris, but her work was not as well received in America. She did, however, become one of the most important purveyors of the new Impressionist paintings, and she encouraged her wealthy friends and associates to purchase the paintings and advised them on which ones to buy. One of her closest friends, Louisine Havemeyer, married to H.O. Havemeyer, a wealthy sugar magnate, took Cassatt's advice seriously, and the Havemeyers, over the course of many years and travels with Cassatt throughout Europe, amassed an impressive collection that eventually was distributed among some of the most prestigious American museums, most notably the Metropolitan Museum of Art. In this way, Cassatt was largely responsible for the Impressionists' paintings coming to the United States.

In 1893 Cassatt was invited to paint a huge mural for the World's Columbian Exposition in Chicago. The three panels of this masterpiece, depicting the lives of women and children, were named ''Young Women Plucking the Fruits of Knowledge and Science,'' ''Young Girls Pursuing Fame'' and ''Music and Dance.'' Unfortunately, not only was the mural hung so high that it was hard to view, but it also apparently was lost or destroyed upon the close of the exhibition.

After 1900, Cassatt seemed to favor pastel over oil, and she limited her subjects almost entirely to women and children. She stopped painting completely around 1912 because of her failing eyesight, and she died of diabetes in 1926.

Mary Cassatt was the only American to exhibit in the Impressionist shows. She was one of the few women in the world to receive high critical acclaim for her paintings during her lifetime. She not only effected a new respect for the abilities of women painters, but she also assisted in the birth and acceptance of a whole new approach to painting, Impressionism.

BERTHE MORISOT (French, 1841–1895)

Mary Cassatt was not the first woman, however, to participate in the Impressionists' exhibits. The work of Berthe Morisot was included in seven of

the eight exhibits. While this clearly indicates her acceptance into the group by the other painters, her work did not meet with the commercial and critical success that Cassatt's did. Morisot received many negative reviews, and her paintings were often unfavorably compared to Cassatt's. Morisot was a more experimental painter than Cassatt, introducing more daring canvasses, thereby opening herself up to harsher review.

Berthe Morisot, like Cassatt, was brought up in a well-to-do family. She and her sister, Edma, were encouraged in their artistic pursuits, and in 1861 they both met Jean-Baptiste-Camille Corot and studied with him informally. This was extremely significant as Corot did not take students, and his only exceptions were the Morisot sisters. Corot encouraged them to paint landscapes outdoors rather than finish them in the studio, and both Edma and Berthe were thereby introduced to and taken in by the Impressionist approach.

When Edma married in 1869, she stopped painting. Berthe married Edouard Manet's younger brother, Eugène, in 1874, and continued to paint and exhibit, greatly encouraged and supported by her husband, who spent much of his time promoting his wife's work and helping to organize exhibits. Her husband's brother contributed to this atmosphere of love and support, which allowed her to devote herself to her painting, even as a wife and mother. Morisot herself was usually dissatisfied with her own work, but she was one of the most highly respected among her fellow Impressionists. Manet, Pissarro, Renoir and Monet, among others, greatly admired her paintings. She was generally regarded as daring in her compositions—she continued to experiment and employ innovative techniques until her untimely death at the age of fifty-four in 1895. It is interesting to speculate on her success as a painter had she lived longer. Would her mature paintings have rivaled ones Monet completed after her death—his Rouen Cathedral series and his water lily paintings, images that today practically define Impressionism? Would her reputation as one of the most important Impressionists have been established earlier? Would her associations with Monet and Renoir (in which they were as much moved by her work as she was by theirs—Monet owned five of Morisot's paintings) have led in later years to an accepted critical opinion of her as their peer?

Today, at last, Berthe Morisot has begun to receive her justly deserved acclaim as one of the most important, most influential, of all of the Impressionists.

EVA GONZALÈS (French, 1849–1883)

Edouard Manet was to teach and influence another talented woman Impressionist besides Morisot. Eva Gonzalès became Manet's student, model and friend in 1869. Gonzalès was born to parents very involved in the arts: her mother was a musician and her father a well-known novelist. She studied with Charles Chaplin at the age of sixteen (the same instructor who taught Cassatt for a short time), but her artistic mentor was definitely Edouard Manet.

Gonzalès married Henri Guérard, an artist, in 1879. She bore a son four years later and tragically died suddenly that same year at the age of thirty-four. Eva Gonzalès had too short a life to gain the notoriety that came to other painters of the era, but she did exhibit at the Salon in 1869 and 1870 and received good reviews. She was not included in any of the Impressionists' exhibits, but her work can be associated with them through her broad brushstrokes and her choice of modern-day scenes as her subjects.

After Gonzalès' death, Henri Guérard and her father organized an exhibition of her paintings that contained eighty-five works—an impressive number for such a brief career.

MARIE BRACQUEMOND (French, 1841–1916)

Marie Bracquemond did not receive the personal support from her husband or family that was so familiar to Morisot and Gonzalès, although she married, in 1869, another artist, the well-known and respected etcher Félix Bracquemond. This marriage, however, enabled her to make important artistic contacts, previously unavailable to her in her uncultured background, and her husband taught her etching, though she only completed nine etchings in her lifetime. She became passionately interested in *plein-air* painting in the late 1870s, and she began painting outside of the studio shortly before her inclusion in the fourth of the Impressionists' exhibitions. Félix Bracquemond was strongly opposed to the Impressionists' methods, and although his etchings were included in their first, fourth and fifth exhibitions, they shared nothing in common with the Impressionist paintings. He was dismayed at his wife's continued involvement with the group (Marie's work was also displayed in the fifth and eighth Impressionists' exhibits) and her use of the Impressionist technique and palette. He did not encourage Marie to exhibit her work—in fact, Marie's paintings were not even shown to other artists who visited their home. Finally, because of the extraordinary pressure Félix Bracquemond exerted on his wife, Marie abandoned painting altogether around 1890.

Although Bracquemond's paintings had little opportunity for review by her contemporaries, they were noticed by Gustave Goetschy in the Impressionists'

fifth exhibition. Goetschy wrote for *Le Voltaire* in 1880, ''Bracquemond, who draws and paints ravishingly, exhibits a good portrait and a charming *plein-air* study.'' Her later works shown in the eighth exhibition did not find favor with Jules Vidal, however, as he described her in an article written for *Lutéce* as ''...Marie Bracquemond, a lady who must excel in embroidering slippers and who wastes her time copying magazine illustrations.'' Bracquemond's unhappy circumstances at home obstructed her quest to express herself as a painter, as an Impressionist, and her small body of work has been largely forgotten and ignored. This poster book regrettably presents only one of her very fine paintings, *Tea Time*, from the collection of the Musée de Petit Palais in Paris, but it serves to illustrate that her fine and special talent created paintings of value equal to those of her better-known contemporaries.

LILLA CABOT PERRY (American, 1848(?)-1935)

Impressionism found its practitioners in America as well as France, and several women painters employed its techniques to create many remarkable works. Lilla Cabot Perry may be the best known of the American women Impressionists. She came from a prominent Boston family and in 1874 married Thomas Sergeant Perry, the grandnephew of Commodore Matthew Perry and a professor of eighteenth-century English literature.

Lilla Cabot Perry studied painting with both Robert Vonnoh and Dennis Bunker, but she was most greatly influenced by Claude Monet, whom she met in 1889. While Monet did not take formal students, he advised Perry on her painting, and the Perrys for ten summers lived next door to Monet's house in Giverny.

The Perrys also lived in Japan for several years, where Mr. Perry taught, but most of their lives were spent in Boston and at a summer home in Hancock, New Hampshire. Most of Lilla Cabot Perry's work in her later years were landscapes done of various New England settings.

Perry's talents were not limited to her able brushwork: she published four volumes of her poetry, and she shared in common with Mary Cassatt a zeal for promoting Impressionism in the United States. She was the founder and first secretary of the Guild of Boston Artists.

MILDRED GIDDINGS BURRAGE (American, 1890–1983)

Mildred Giddings Burrage was another American painter who employed the Impressionists' technique in painting landscapes. She was born in Portland, Maine, graduated from the Mary C. Wheeler School in Providence, Rhode Island, and studied art history at the Fogg Art Museum at Harvard. She traveled to France in 1909 with Mary C. Wheeler and visited her home in Giverny, the site of Claude Monet's famous estate and Lilla Cabot Perry's summer home. Burrage continued to summer in France until the outbreak of World War I, and she studied in Paris at the Académie Colarossi and La Grande Shaumiére. Her work was shown in Paris at the Salon d'Automne and at the Salon des Artistes Indépendants. Her Impressionist style of painting was firmly rooted in her works during this period, supported by the recognition she received at these exhibitions.

Between the World Wars, Burrage traveled to Nevada, California, Arizona, Mexico and Guatemala, and continued to spend time in Maine. During this time her work was exhibited at the Museum of Fine Arts in Boston, the Art Institute of Chicago, the Detroit Institute of Art and the Pennsylvania Academy of Fine Art.

During World War II, Burrage served as a counselor to women at the New England Ship Building Corporation in Portland, Maine. She later counseled at Halloran Hospital on Staten Island, and she finally became the medical artist for Dr. Arthur Devoe, who was the director of the Institute of Ophthalmology in New York. It was during her residence in New York that she saw an exhibit of paintings by the abstract expressionist Jackson Pollack, whose work had a profound effect on Burrage. For the rest of her career, Burrage abandoned the Impressionist style and instead incorporated abstract approaches. Her canvasses were especially noted by Dorothy C. Miller of the Museum of Modern Art who championed her ''Mica Paintings,'' paintings in which Burrage used mica from the state of Maine on her canvasses.

Mildred Burrage never married. She had a very independent mind and explored many areas of interest in her long life. She became very involved in her later years with historic preservation in the state of Maine and was a member of Maine's first advisory board on historic sites in the early 1960s.

Mildred Giddings Burrage is not a painter readily acknowledged outside of a very small circle of art authorities. However, she clearly was not only a talented Impressionist painter, but also a painter who maintained an open eye and a willingness to learn and to be moved. To change her style of painting so completely from Impressionistic to abstract is a testament to her vital dedication to her art and its growth. *View of Camden Hills,* reproduced in this book, is a fine example of one of her Impressionist landscapes.

CECILIA BEAUX *(American, 1855–1942)*

Cecilia Beaux, born in Philadelphia and raised by her grandmother and aunts who were very supportive of her artistic pursuits, studied with local painters and began exhibiting as early as the late 1870s. She traveled to Paris in 1888 and enrolled in the Académie Julian and later spent a summer in Brittany, where her work developed a freer stroke and a more expressive quality. She exhibited six portraits at the Paris Salon in 1896 and was elected as an Associate of the Société Nationale des Beaux Arts.

While Beaux was very conscious of not imitating any particular artist or even an artistic movement, the effect of the Impressionists is evident in her treatment of light and color in her canvasses. She specialized in figure studies, and through her many travels and lectures, she received much recognition. Her reputation as a portraitist was well established by 1900, and she painted the likenesses of many prominent political and popular Americans, including Mrs. Theodore Roosevelt and Mrs. Andrew Carnegie. She was one of the few women artists of her day who enjoyed large commercial success, perhaps because she was unafraid to promote herself. In 1925, in a clear testament to her singular talent, Cecilia Beaux was the first American woman to be asked to paint a self portrait for the Uffizi's gallery of artists.

JENNIE AUGUSTA BROWNSCOMBE *(American, 1850–1936)*

Jennie Augusta Brownscombe also enjoyed commercial success during her lifetime as she had much of her work—over 100 canvasses—published in calendars and magazines. Born in a log cabin in Wayne County, Pennsylvania, she went to New York to study at the School of Design for Women of the Cooper Union for the Advancement of Science and Art, and she helped found the Art Students League in 1875. Brownscombe was strong in ''story'' or ''genre'' paintings, popular at the end of the nineteenth century. Her images, coupled with their titles, told a story or depicted a historical event.

However, as evidenced by her painting *Apple Orchard in May* reproduced in this book, Brownscombe employed a technique influenced by the Impressionists at one stage in her career. She certainly was not ignorant of the movement: she visited Paris in 1882 and studied there with Henry Mosler, one of the very few painters to accept women students into his studio.

HELEN TURNER *(American, 1858–1958)*

Helen Turner as a young girl lived in the South during the Civil War, when her eldest brother was killed and several of her family's houses were burned down. After her mother died in 1865 and her father died in 1871, Helen Turner was raised by her uncle in New Orleans, where she became interested in art. She moved to New York to study at the Art Students League, Cooper Union and Columbia University, and in 1921 she was only the third woman to be elected to full Academician status by the National Academy of Design. Turner's early works were portrait miniatures, but she eventually moved into full-sized oils.

Beginning in 1906, Turner spent her summers at Cragsmoor, an art colony in upstate New York, and she built a summer home there which she inhabited until she sold it it 1941. She spent the last thirty years of her life in New Orleans.

Helen Turner is not a name usually associated with the Impressionists, but again, as with the work of Jennie Augusta Brownscombe, the Impressionists' influence is clearly noticeable in *Morning News,* Turner's masterpiece reproduced in this book.

It is the aim of this poster book, in presenting the works of these nine women Impressionists, to bring their paintings to the attention of the admirers of that school, not so that they are judged separately or deemed to be better or worse than the paintings by the men Impressionists, but so that their contribution to the body of Impressionist work is remembered and valued, and so that it shares equal historical importance.

Sources

Adler, Kathleen. *Unknown Impressionists.* Oxford: Phaidon Press, Limited, 1988.

Bullard, E. John. *Mary Cassatt: Oil and Pastels.* New York: Watson-Guptill Publications, 1976.

Editions de la Réunion des Musées Nationaux. *Impressionist and Post-Impressionist Masterpieces at the Musée d'Orsay.* New York: Thames and Hudson, 1987.

Fine Arts Museums of San Francisco. *The New Painting: Impressionism 1874–1886).* Geneva: Richard Burton SA, Publishers, 1986.

Garb, Tamar. *Women Impressionists.* New York: Rizzoli, 1987.

Heller, Nancy G. *Women Artists: An Illustrated History.* New York: Abbeville Press, 1987.

National Museum of Women in the Arts. *National Museum of Women in the Arts.* New York: Harry N. Abrams, Inc., 1987.

Stuckey, Charles F., and William P. Scott. *Berthe Morisot: Impressionist.* New York: Hudson Hills Press, 1987.

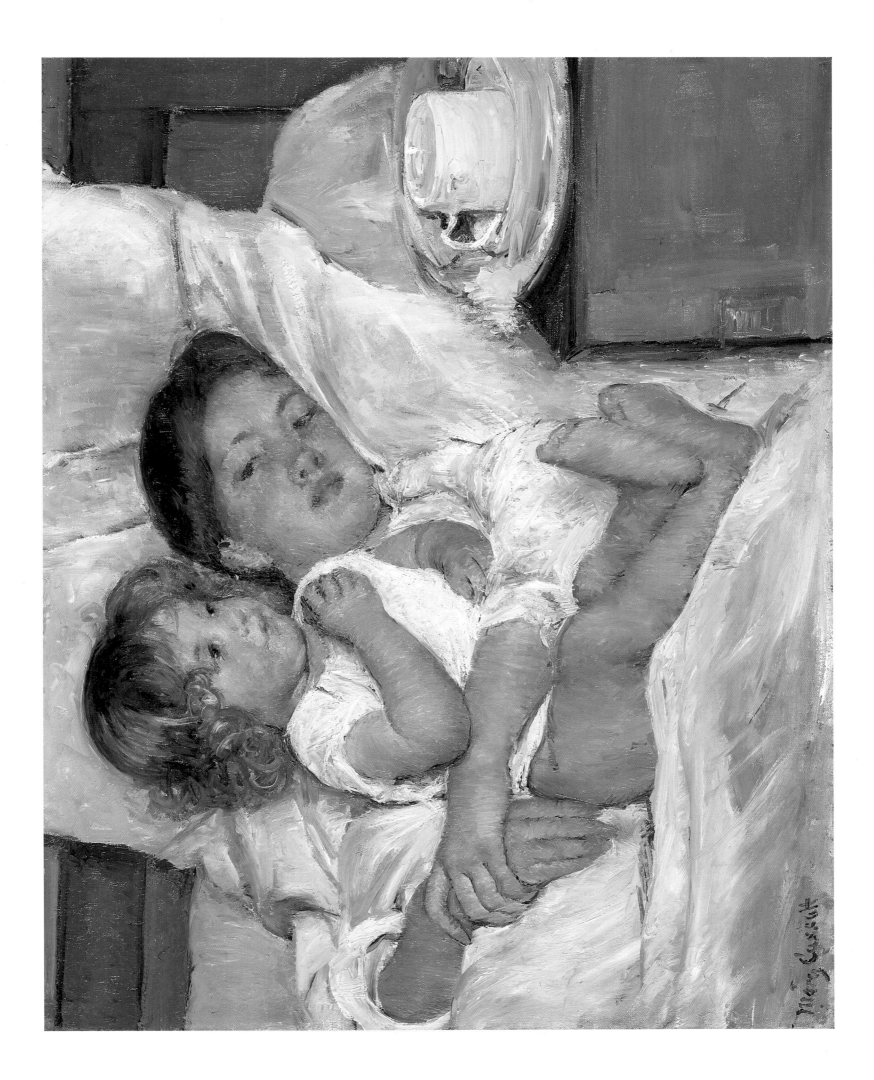

Mary Cassatt (American, 1844–1926)
Breakfast in Bed, 1897
Oil on canvas, 23×29 in.
The Huntington Library, Art Collections and Botanical Gardens
The Virginia Steele Scott Collection

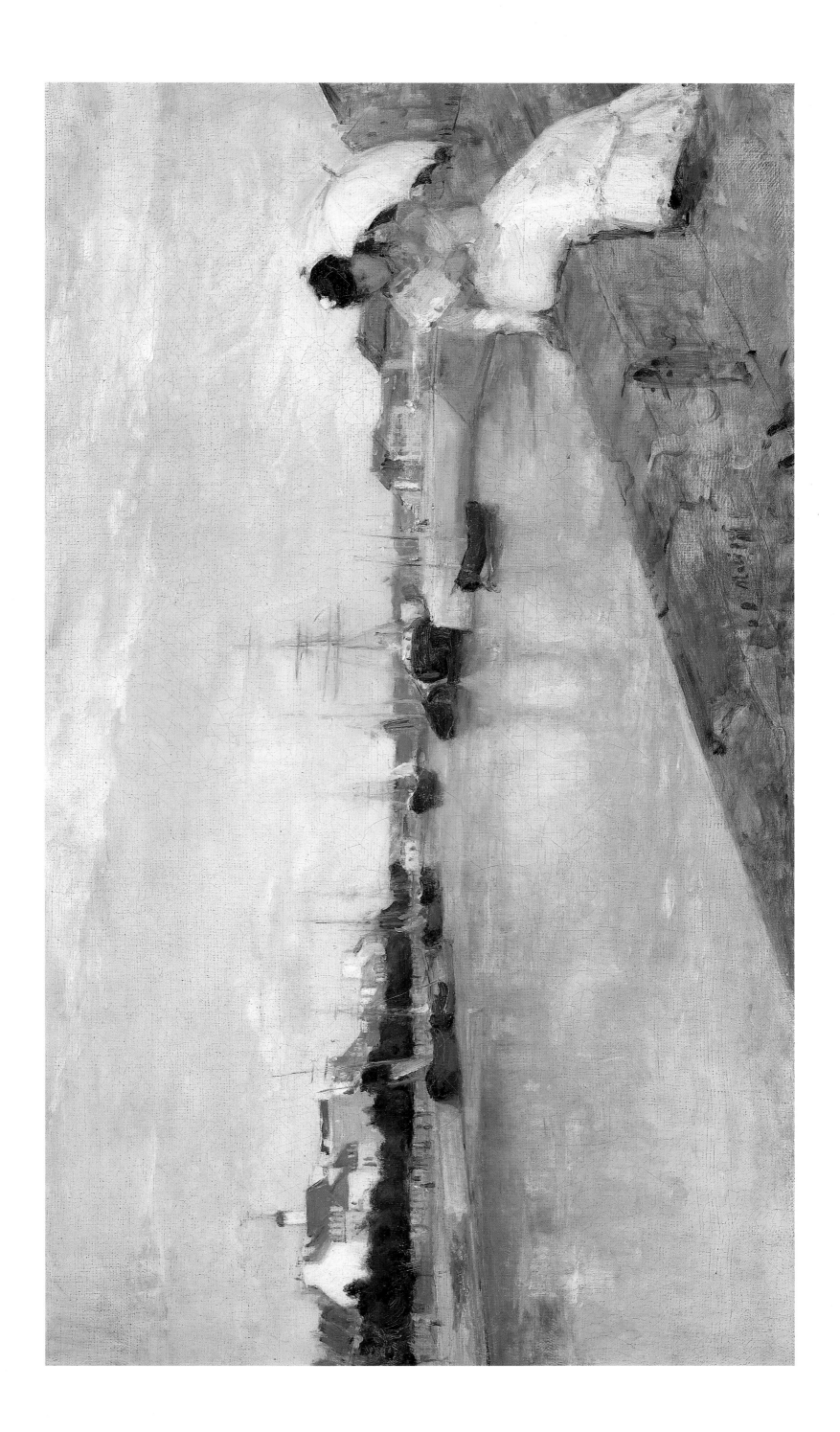

Berthe Morisot (French, 1841–95)
The Harbor at Lorient, 1869
Oil on canvas, 17⅛ ×28¾ in.
National Gallery of Art, Washington
Ailsa Mellon Bruce Collection

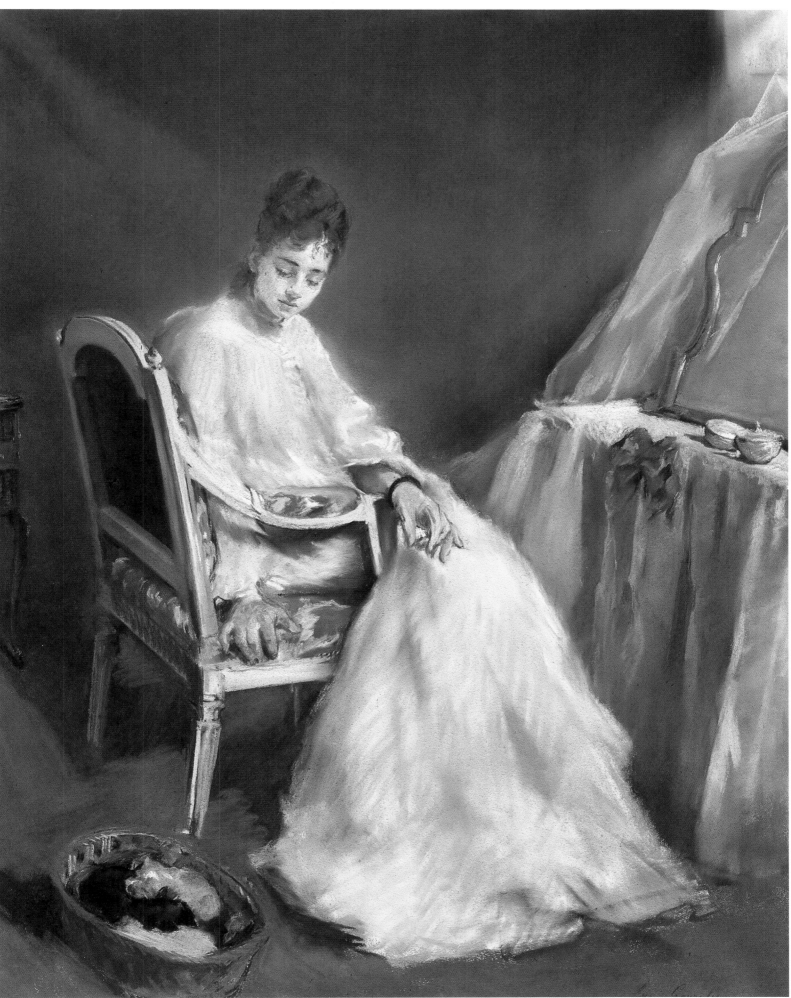

Eva Gonzalès, (French, 1849–83)
Pink Morning, 1874
Pastel on paper, 35½×28½ in.
Musée du Louvre, Cabinet des Dessins, Paris

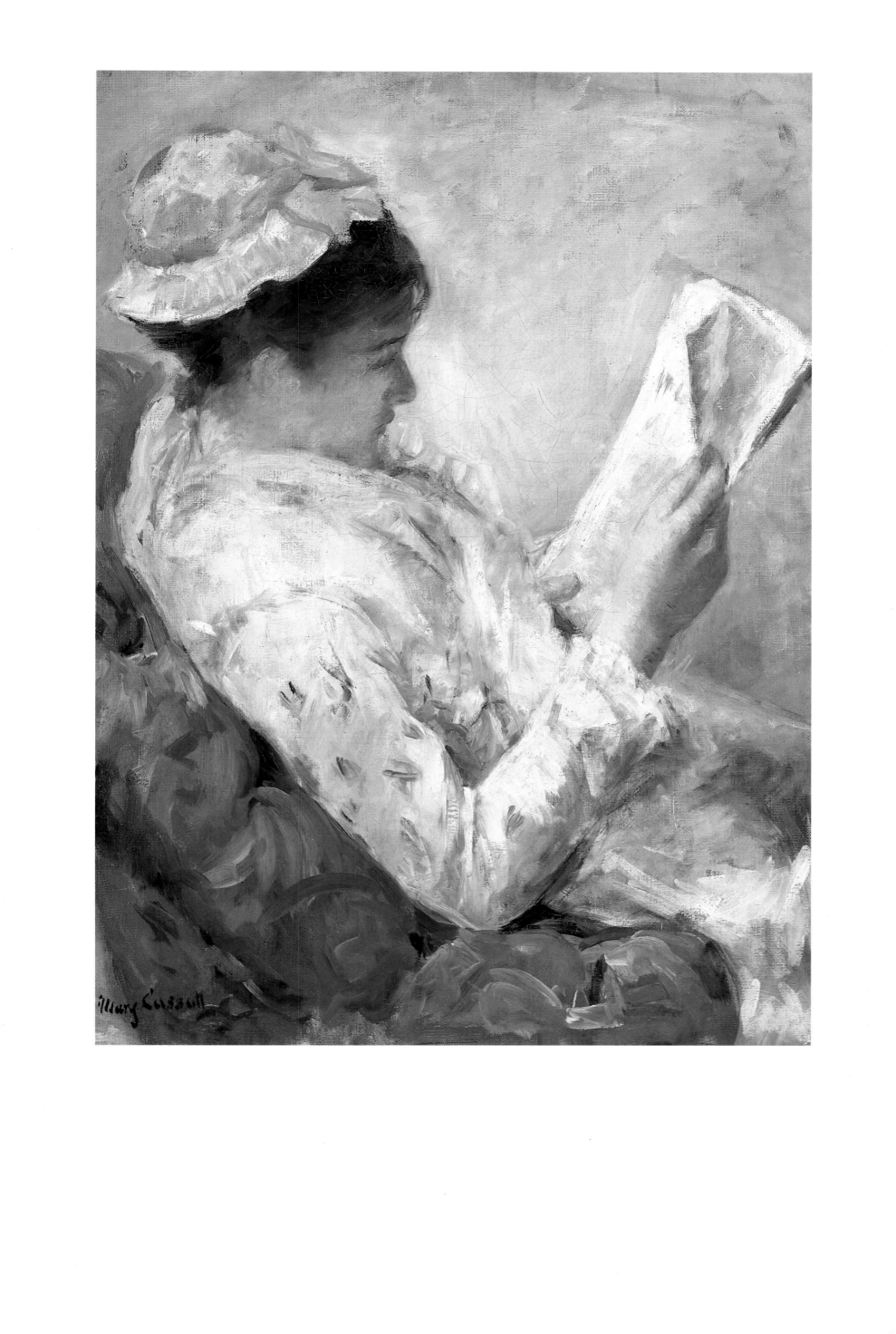

Mary Cassatt (American, 1844–1926)
*Woman Reading (Portrait of Lydia Cassatt,
the artist's sister)*, 1878–9
Oil on canvas, 32×23½ in.
Joslyn Art Museum, Omaha, Nebraska
Museum Purchase

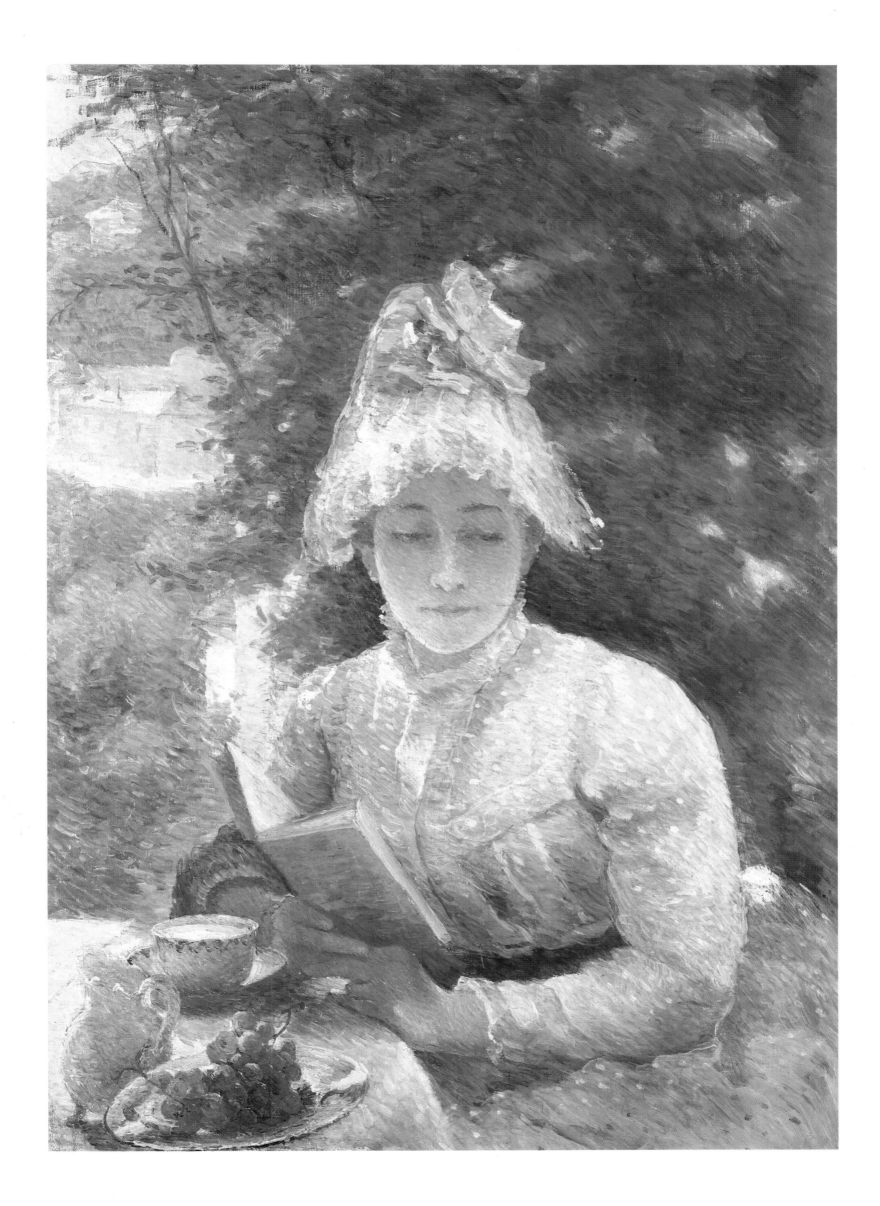

Marie Bracquemond (French, 1841–1916)
Tea Time, 1880
Oil on canvas, 32×24 in.
Musée de Petit Palais, Paris

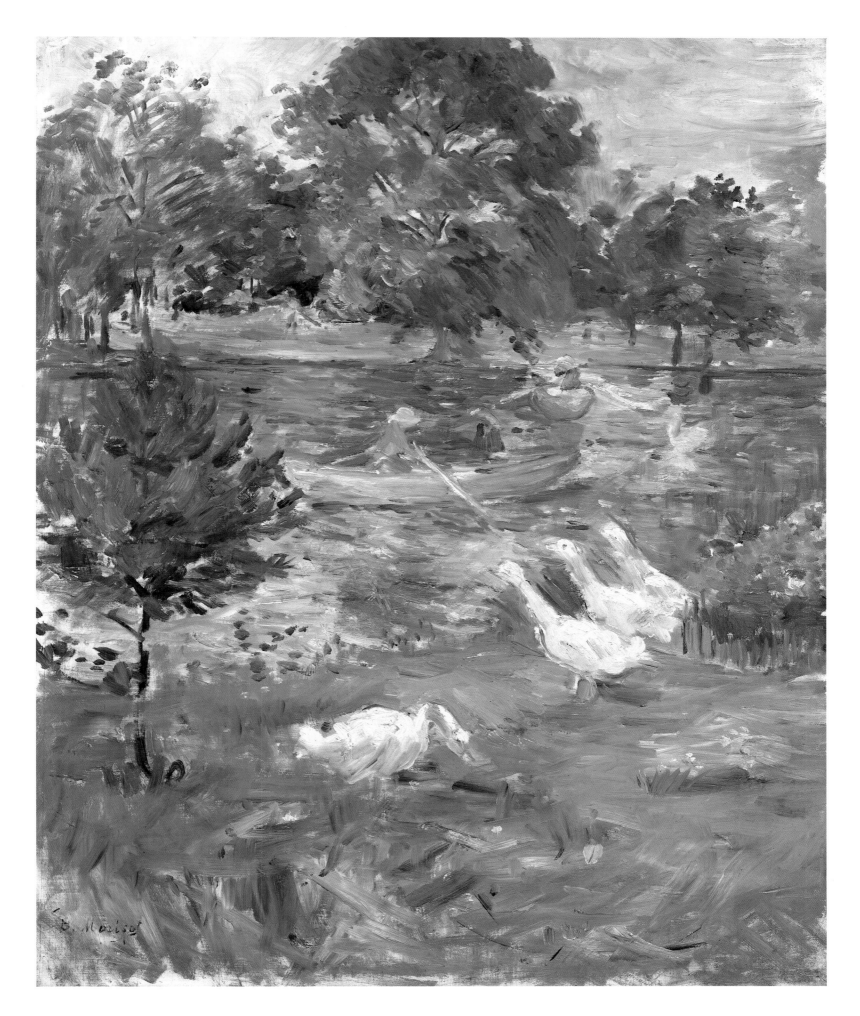

Berthe Morisot (French, 1841–95)
Girl in a Boat with Geese, c. 1889
Oil on canvas, 25¾×21½ in.
National Gallery of Art, Washington
Ailsa Mellon Bruce Collection

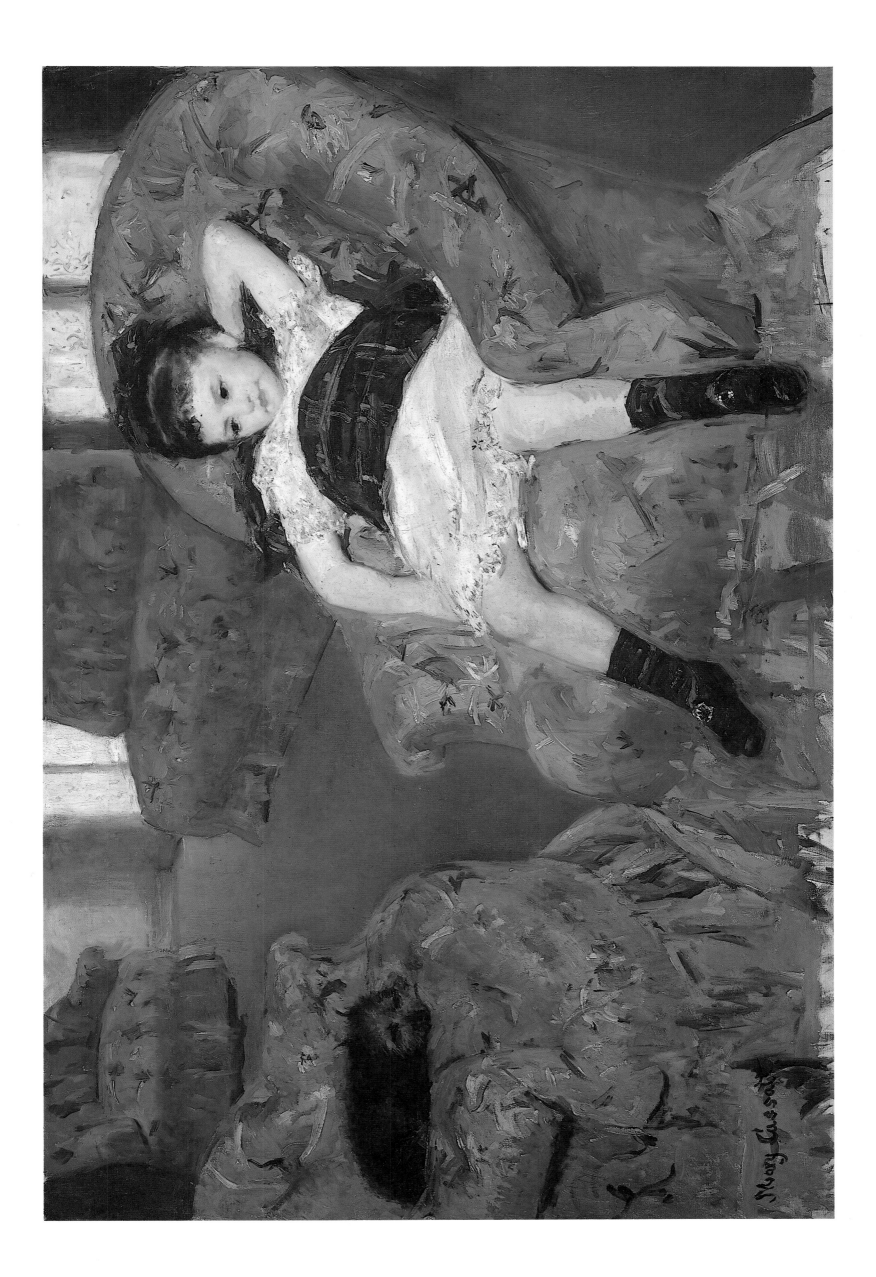

Mary Cassatt (American, 1844–1926)
Little Girl in a Blue Armchair, 1878
Oil on canvas, 35½×51⅛ in.
National Gallery of Art, Washington
Collection of Mr. and Mrs. Paul Mellon

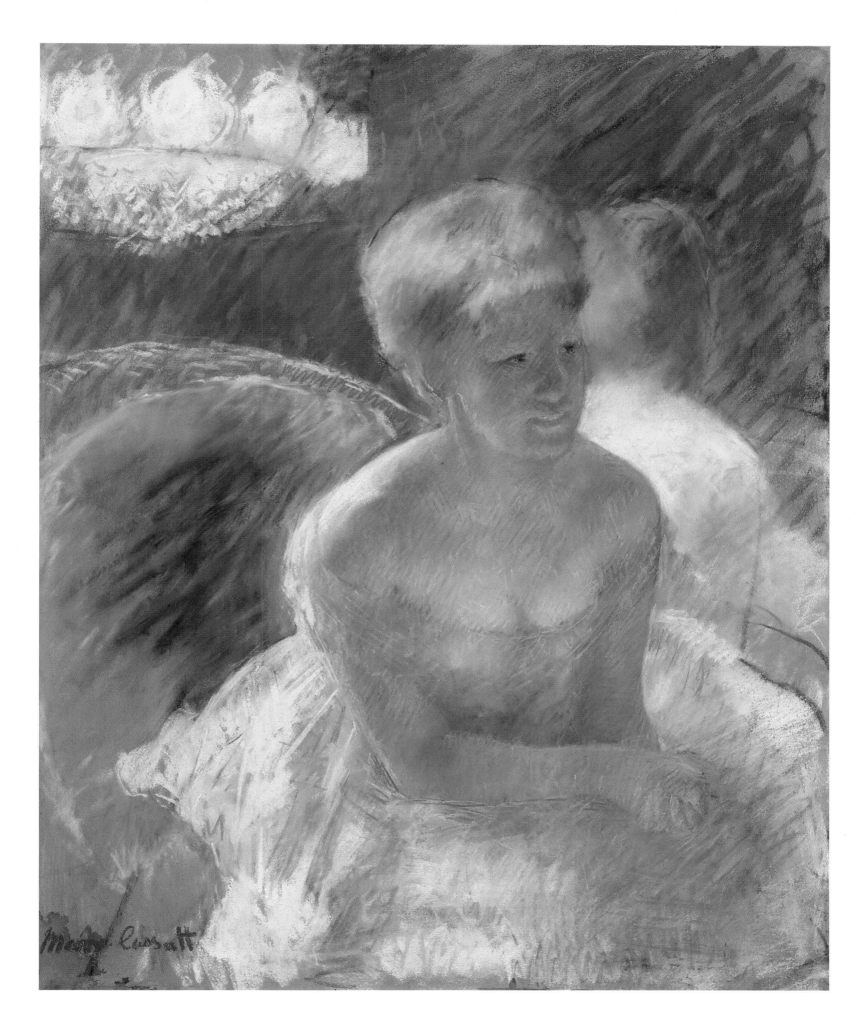

Mary Cassatt (American, 1844–1926)
Au Theâtre, 1879
Pastel on paper, 21⅝ ×17¾ in.
The Nelson-Atkins Museum of Art, Kansas City, Missouri
Anonymous Gift

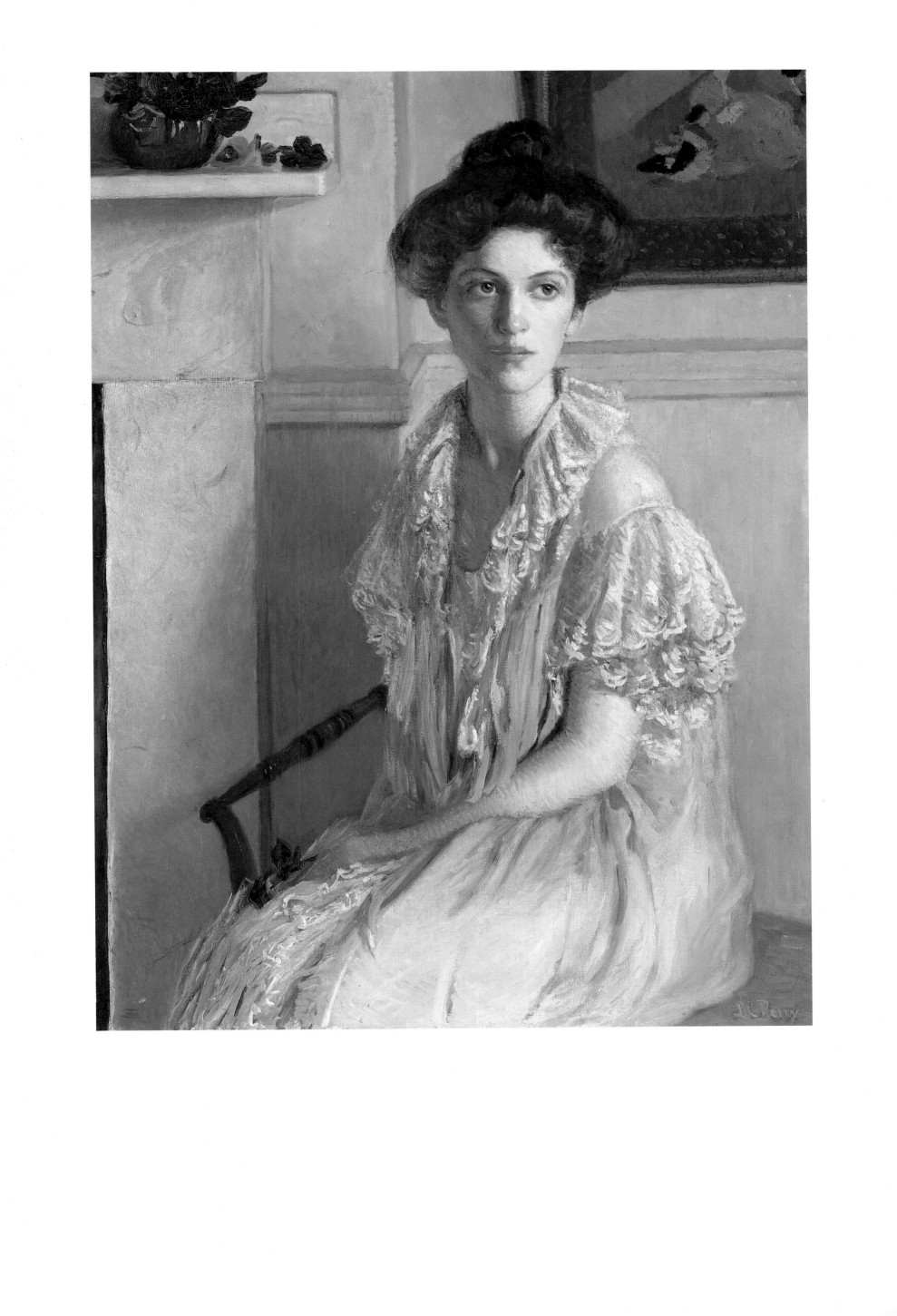

Lilla Cabot Perry (American, 1848–1935)
Lady with a Bowl of Violets
Oil on canvas, 40×30 in.
The National Museum of Women in the Arts
Gift of Wallace and Wilhelmina Holladay

Berthe Morisot (French, 1841–95)
In the Dining Room, 1886
Oil on canvas, 24⅛×19¾ in.
National Gallery of Art, Washington
Chester Dale Collection

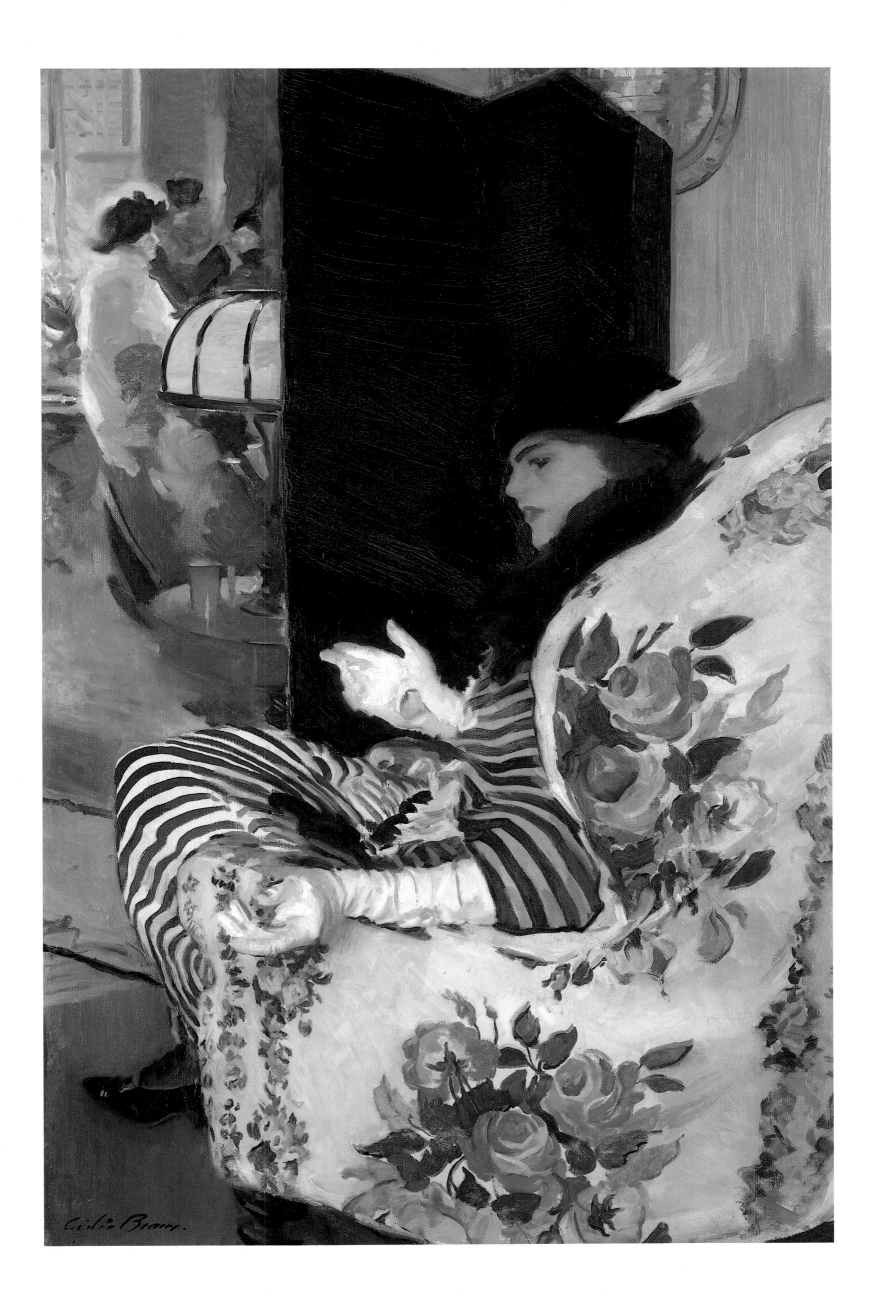

Cecilia Beaux (American, 1855–1942)
After the Meeting, 1914
Oil on canvas, $40^{15}/_{16} \times 28^{1}/_{8}$ in.
The Toledo Museum of Art, Toledo, Ohio
Gift of Florence Scott Libbey

Eva Gonzalès, (French, 1849–83)
The Donkey Ride, c. 1880
Oil on canvas, 32×39½ in.
City of Bristol Museum and Art Gallery
Bridgeman Art Library, London

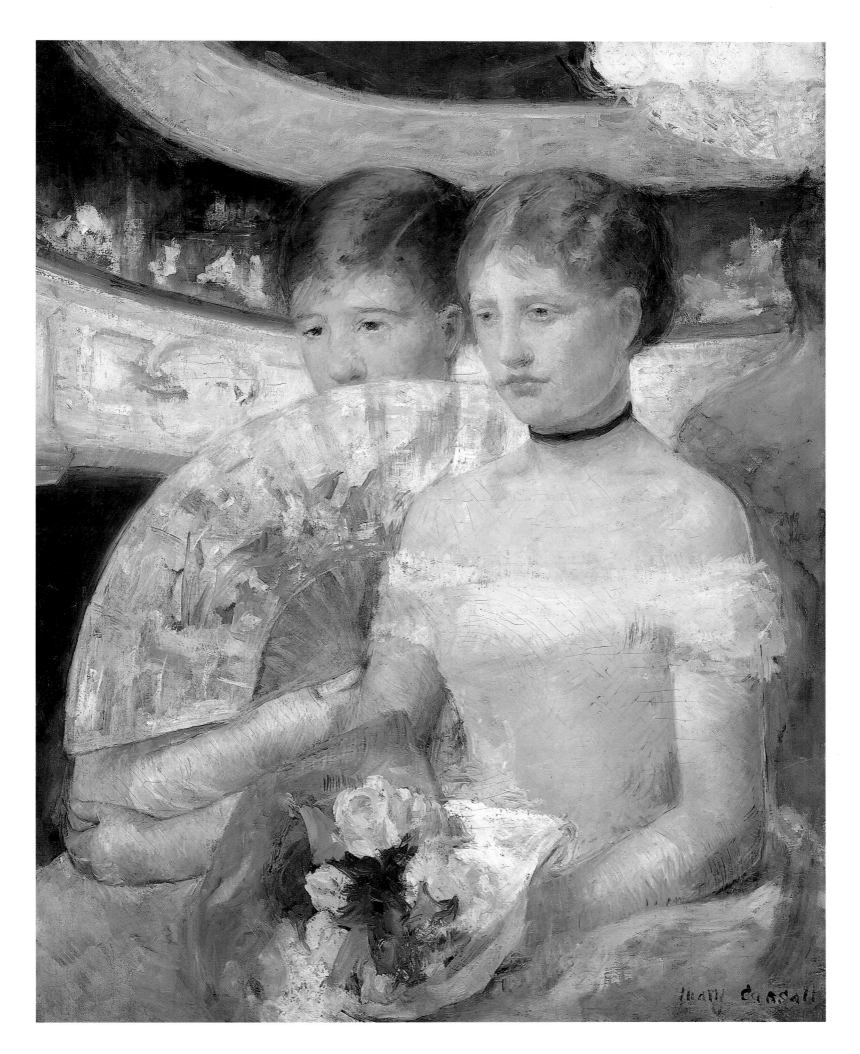

Mary Cassatt (American, 1844–1926)
The Loge, 1882
Oil on canvas, 31½ × 25⅛ in.
National Gallery of Art, Washington
Chester Dale Collection

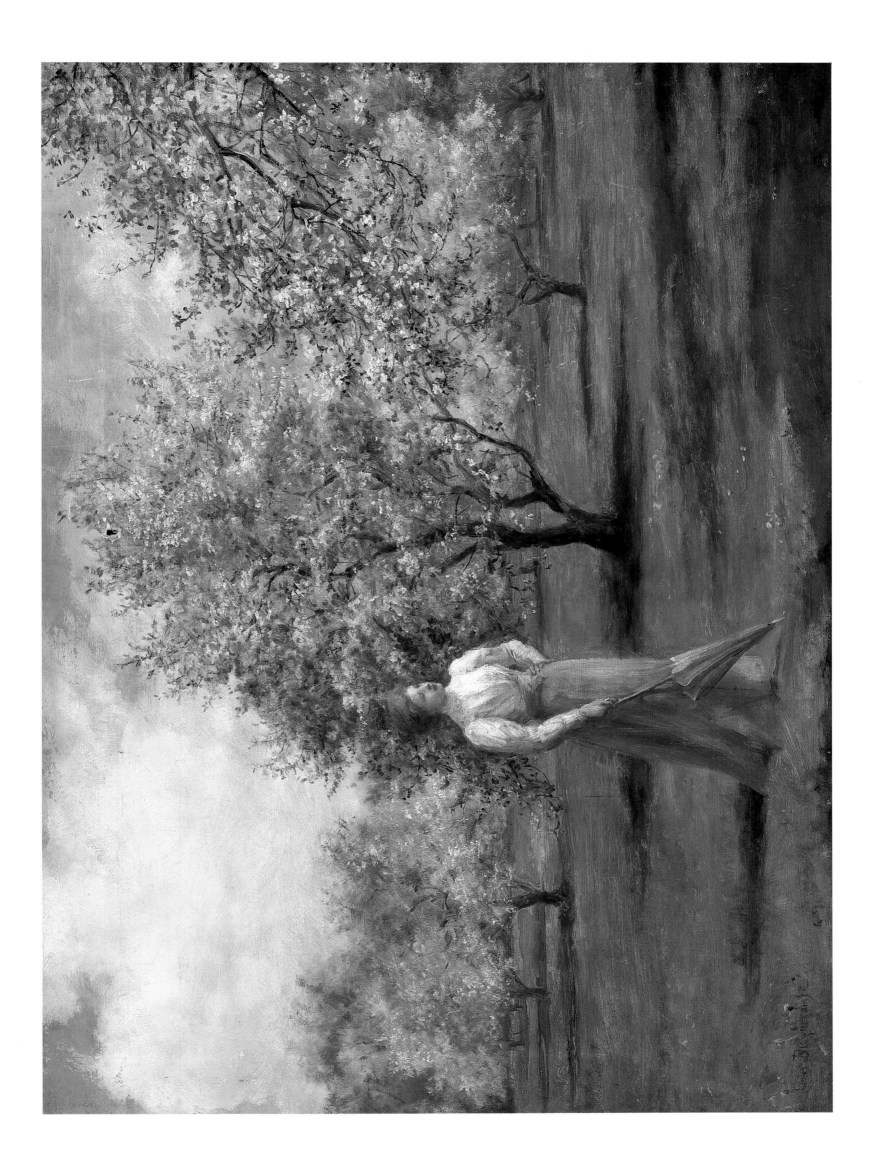

Jennie Augusta Brownscombe (American, 1850–1936)
Apple Orchard in May, c. 1885
Oil on canvas, 17⅜×23¼ in.
Colby College Museum of Art, Waterville, Maine
Gift of Mr. and Mrs. Ellerton M. Jetté

Berthe Morisot (French, 1841–95)
Catching Butterflies, 1873
Oil on canvas, 18×22 in.
Musée d'Orsay, Paris

Mary Cassatt (American, 1844–1926)
The Boating Party, 1893/4
Oil on canvas, 35½×46⅛ in.
National Gallery of Art, Washington
Chester Dale Collection

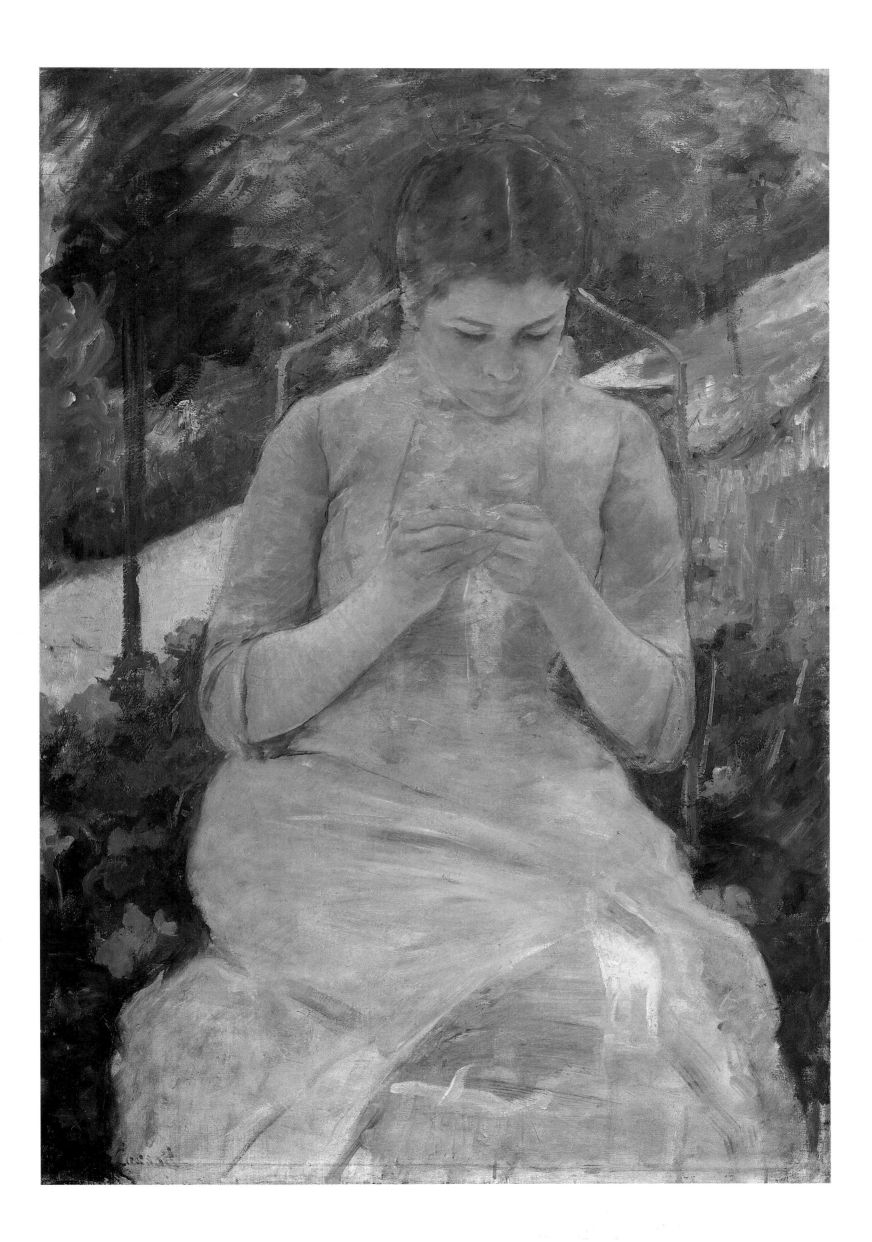

Mary Cassatt (American, 1844–1926)
Woman Sewing, c. 1880–82

Oil on canvas, 36¼×24¾ in.
Musée d'Orsay, Paris
Antonin Personnaz Bequest, 1937

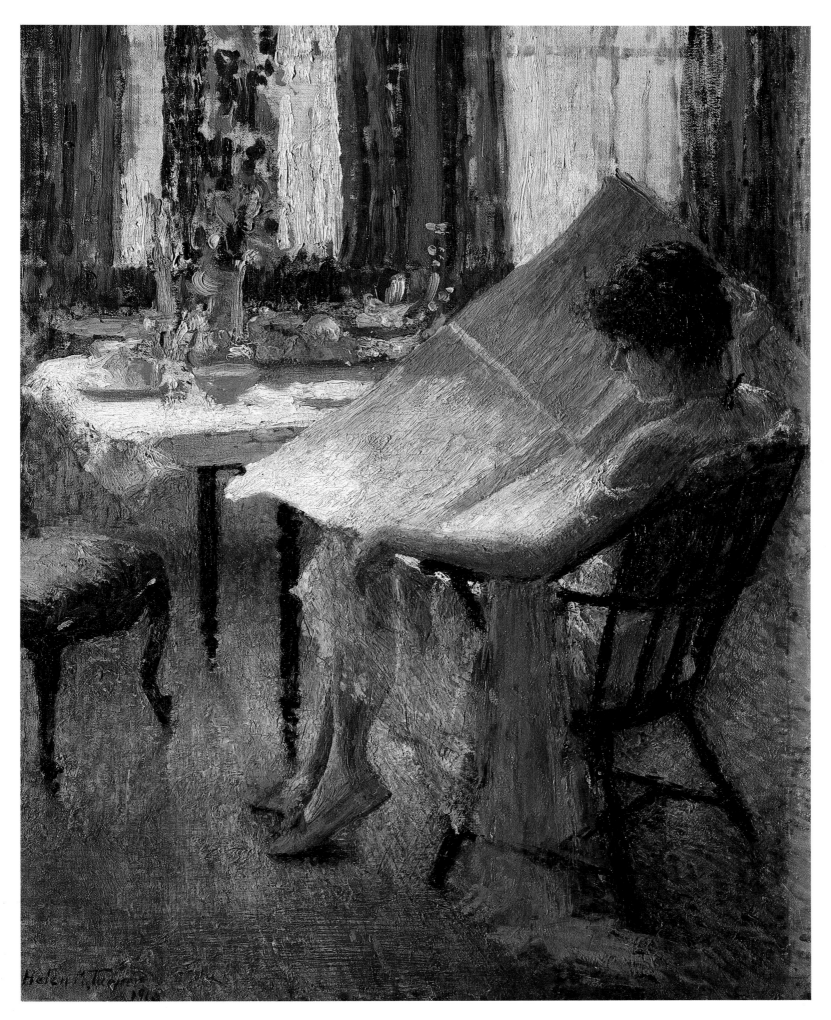

Helen Turner (American, 1858–1958)
Morning News, 1915
Oil on canvas, 16×14 in.
Jersey City Museum, Jersey City, New Jersey

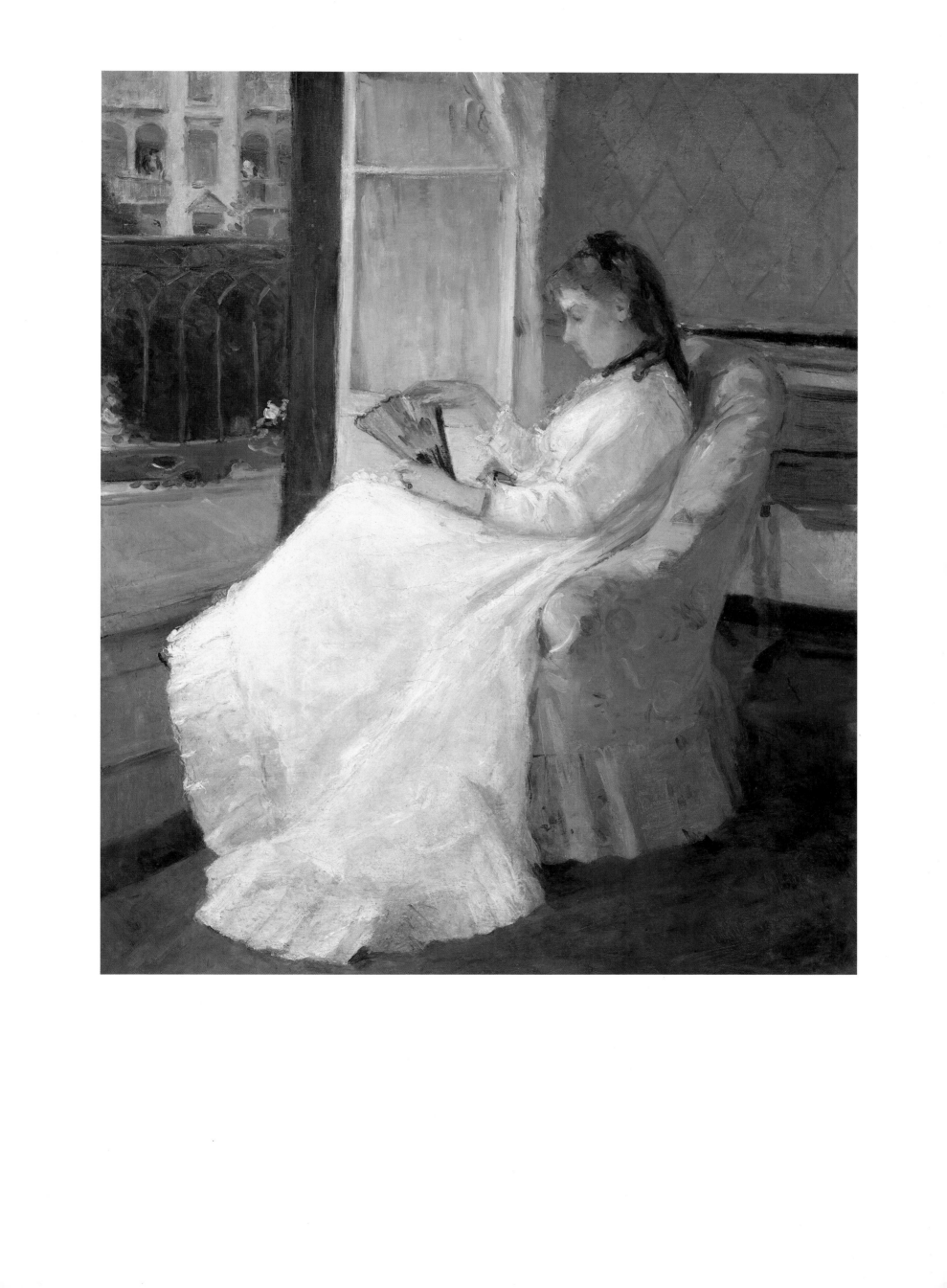

Berthe Morisot (French, 1841–95)
The Artist's Sister at a Window, 1869
Oil on canvas, 21⅝ ×18¼ in.
National Gallery of Art, Washington
Ailsa Mellon Bruce Collection

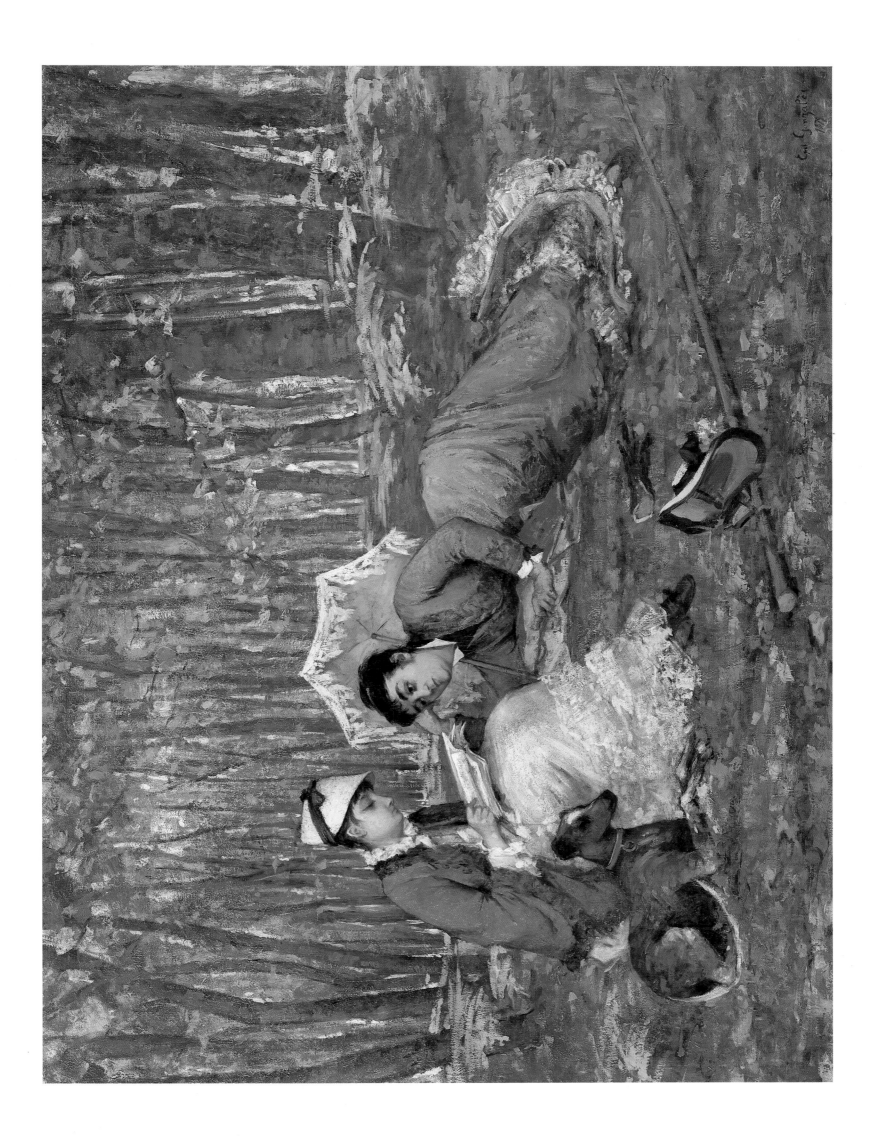

Eva Gonzalès, (French, 1849–83)
Reading in the Forest, 1879
Oil on canvas, 41¾ ×54 in.
Rose Art Museum, Brandeis University, Waltham, Massachusetts
Gift of Mr. and Mrs. Abraham Sonnabend

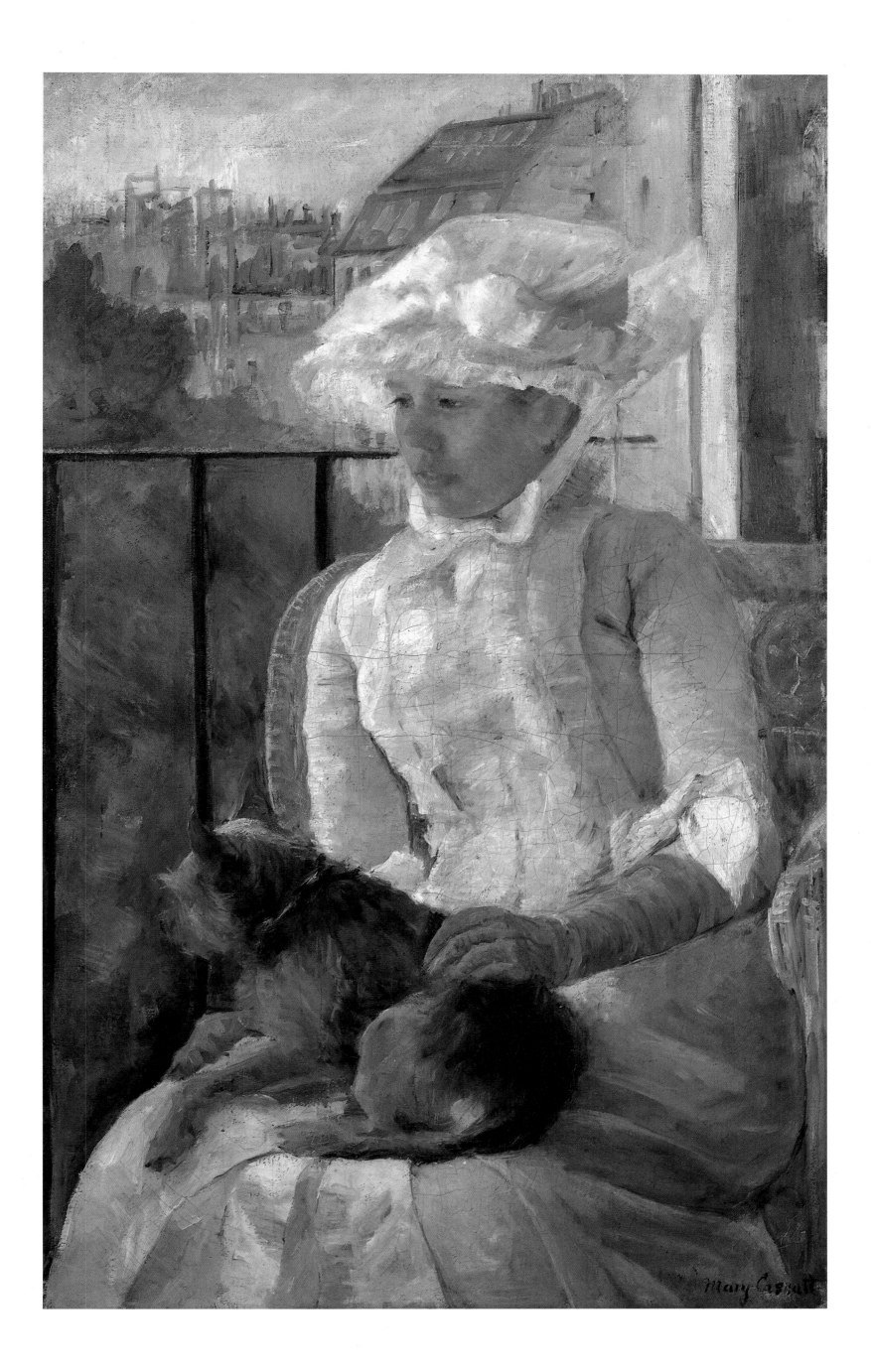

Mary Cassatt (American, 1844–1926)
Susan on a Balcony Holding a Dog, 1880
Oil on canvas, 39×26 in.
The Corcoran Gallery of Art
Museum Purchase, Gallery Fund, 1909

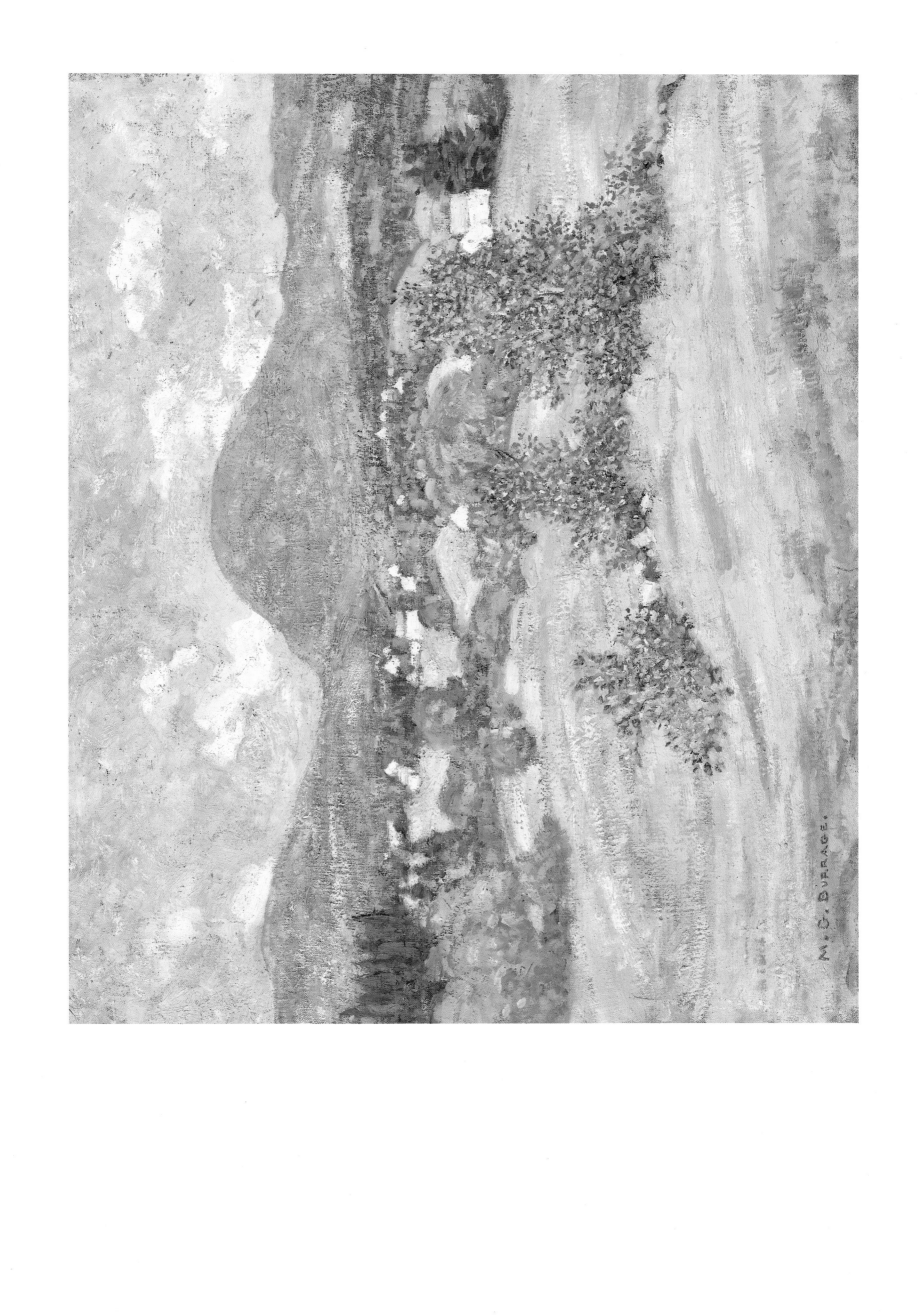

Mildred Giddings Burrage (1890–1983)
View of Camden Hills, c. 1920
Oil on canvas, 22×26 in.
Colby College Museum of Art, Waterville, Maine
Gift of Mildred Giddings Burrage

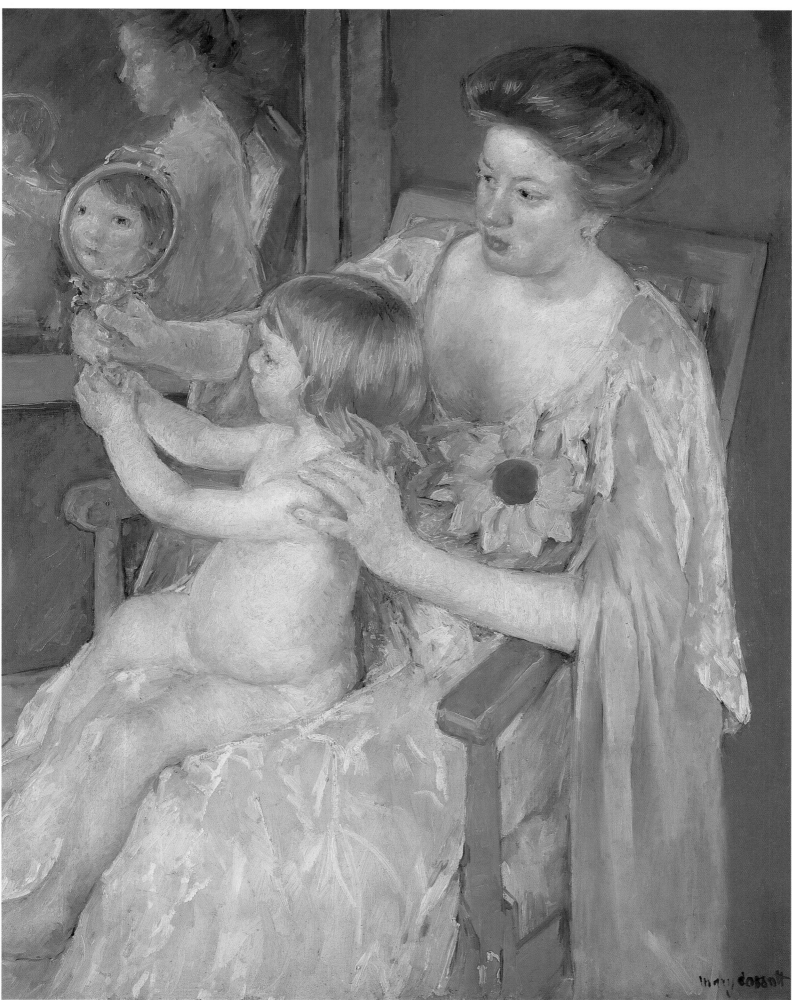

Mary Cassatt (American, 1844–1926)
Mother and Child, c. 1905
Oil on canvas, 36¼ ×29 in.
National Gallery of Art, Washington
Chester Dale Collection

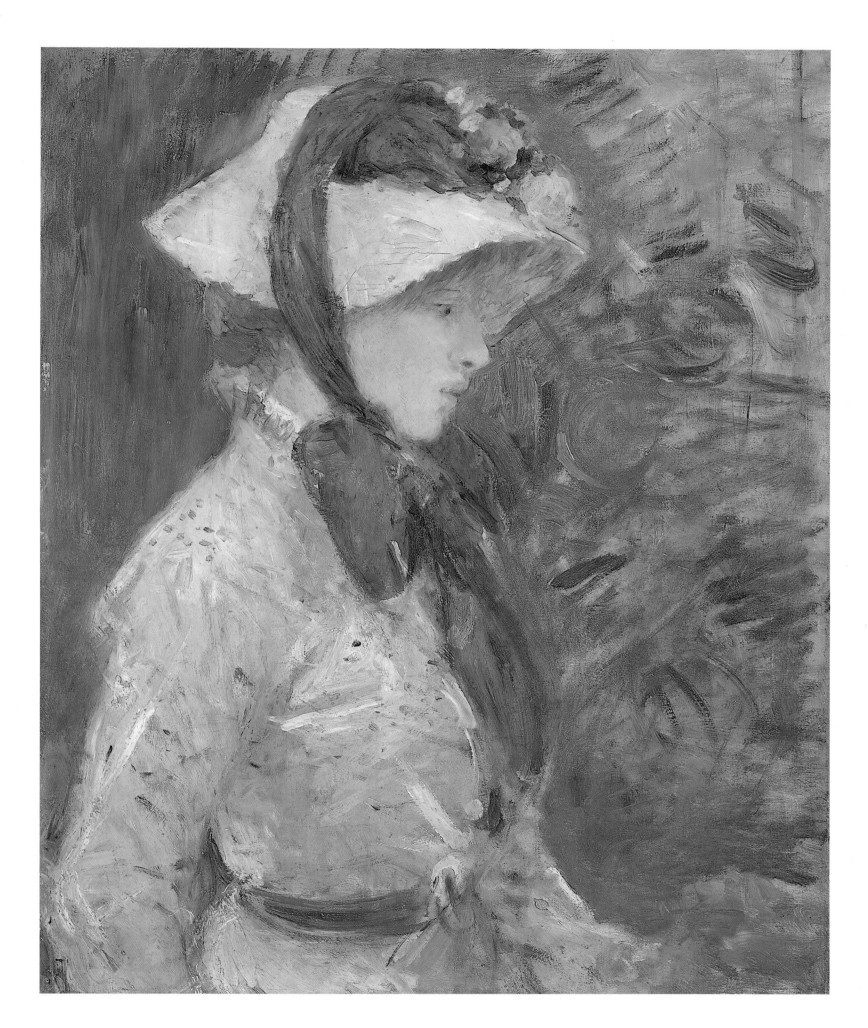

Berthe Morisot (French, 1841–95)
Young Woman with a Straw Hat, 1884
Oil on canvas, 21⅞ × 18⅜ in.
National Gallery of Art, Washington
Ailsa Mellon Bruce Collection

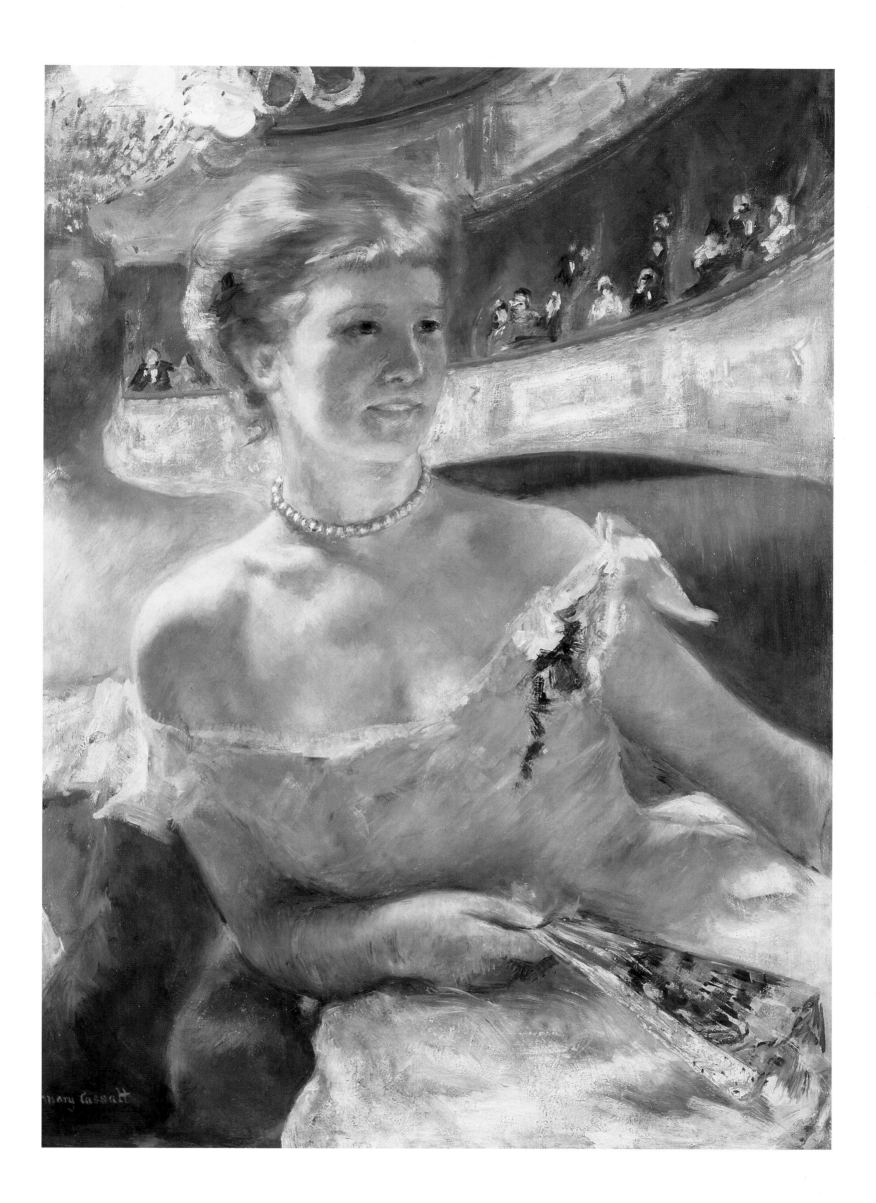

Mary Cassatt (American, 1844–1926)
Woman with a Pearl Necklace in a Loge, 1879
Oil on canvas, 31⅝×23 in.
Philadelphia Museum of Art
Bequest of Charlotte Dorrance White